Mona Lisa

Translated from the French by Alexandra Campbell

First published in Great Britain in 1996 by
Thames and Hudson Ltd, London

© 1995 by Editions Assouline, Paris

Andy Warhol, *Mona Lisa*, 1963
Marcel Duchamp, *L.H.O.O.Q.*, 1919
© ADAGP, Paris 1995

Fernand Léger, *Mona Lisa with Keys*, 1930
© SPADEM, Paris 1995

British Library Cataloguing-in-Publication Data

A catalogue record for this book is available from the British Library

ISBN 0-500-23717-4

Printed and bound in Italy

SERGE BRAMLY

MONA LISA

THAMES AND HUDSON

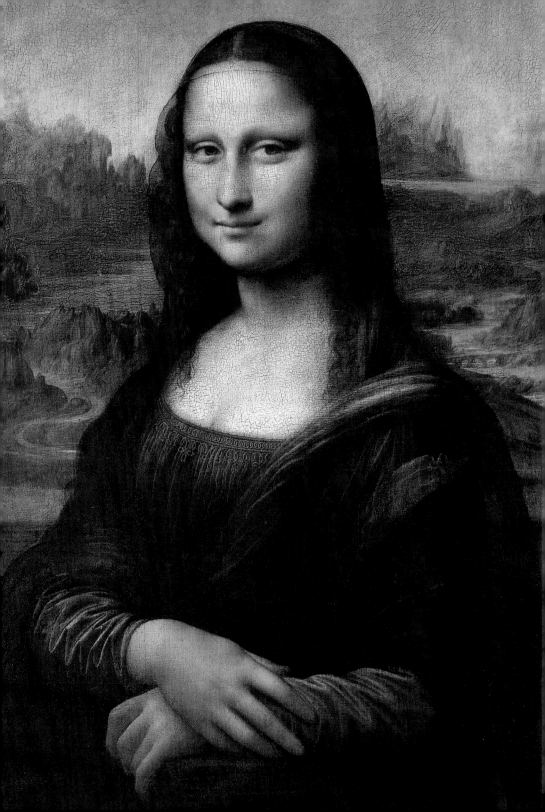

For Marine

t he gaze that does not let you go; the captivating smile, turning in on itself; the *morbidezza* – exquisite softness of flesh; the glaucous atmosphere, the damp twilight of a two-way mirror.... Enclosed in her case of armoured glass, the sphinx-like *Mona Lisa* never tires of presenting a riddle that the visitor, should he or she perchance still pay heed, has lost the will and the means to solve. Too many answers have already been put forward, too much reflection has stifled the work. A visual vampirism is at large. Reproduced *ad infinitum* on postcards, chocolate boxes and souvenir ashtrays, over-used by an idolatrous public, subjected to all the manipulations of journalists and advertisers, caricatured, parodied, decked out in alien trappings, the *Mona Lisa* has been sapped of her substance, has lost her identity. Victim of her fame, she has ceased to be a painting and become a public icon, a cliché. In default of an answer to the riddle she presents, we can at least consider her enigma.

Leonardo da Vinci had a taste for enigmas. He put them to his contemporaries in the form of puzzles and riddles now preserved in his notebooks such as 'Men are treated to great honours and ceremonies they will never know.' Answer: funeral processions. Another was that 'Men walk without moving, they talk to those who are absent, they hear those who do not speak.' The answer: a dream. Plays on words flowed from his pen, as allegories and symbols did from his brush. When he painted the portrait of a woman called Ginevra (meaning juniper), he placed her in the shade of a juniper tree. He

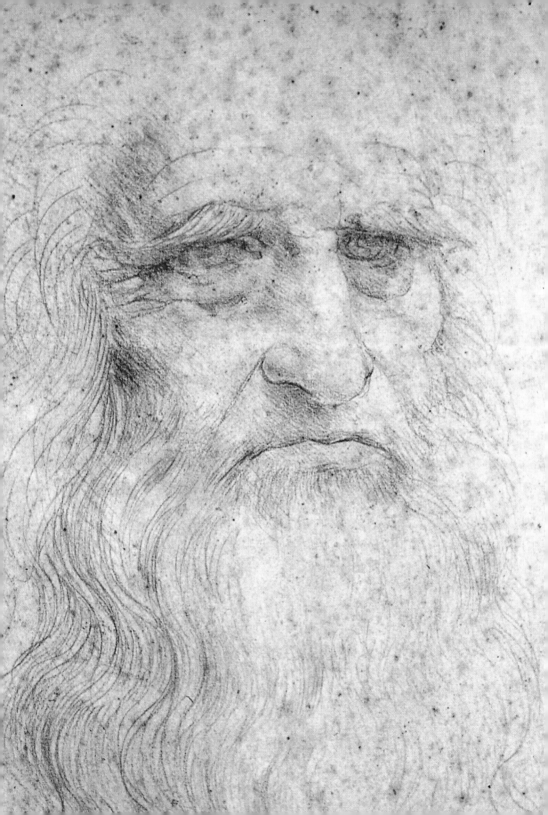

made frequent use of knotted and enlaced motifs (the *Mona Lisa*'s bodice is trimmed with them), for *vinco* in Italian means withe (a flexible willow shoot) thus by extension, a tie or buckle. The translation of *vincolare* is 'to knot'; the knot was to Leonardo da Vinci a form of signature. Leonardo is an artist who needs to be deciphered. We know that he liked to amaze and to intrigue, willingly playing the part of magician. In front of the prelates in the Vatican gardens he released a silvery lizard that he had converted into a dragon. He invented a lion automaton. How far would he not go in the pursuit of mystification? For him *chiaroscuro* and *sfumato* were sometimes as much a way of thinking as a pictorial effect. Strange shadows play over both his work and his life. One meets there so many question marks, one stumbles on so many unknowns, so many ambiguities, that it is at times hard not to suspect the mischievous Leonardo of having deliberately left false trails. Things are so much more beautiful, he said, half-shrouded in shade.

the *Mona Lisa* is no exception to the rule. Who was the model? Who was the patron? Is the title it now goes under legitimate? At what date was the picture painted? How did it enter the royal collections? Historical details are not lacking, but they contradict each other, with the result that the most famous painting in the world has never ceased to fuel the speculation of historians. Nearly five centuries after Leonardo's death, hypotheses and false trails must still be reckoned with. The starting point of all hypotheses is provided by a passage from Vasari first published in 1550, thirty-one years after Leonardo's death: 'For Francesco del

Opposite: Leonardo da Vinci, *Self-Portrait* (detail).

Giocondo, Leonardo undertook to paint the portrait of Mona Lisa, his wife, but after loitering over it for four years, he finally left it unfinished. This work is now in the possession of King Francis of France, and is at Fontainebleau.' There follows a description of the work as detailed as it is adulatory, with this observation: 'Monna Lisa [meaning Madam Lisa] was exceedingly beautiful, and while Leonardo was painting her portrait, he took the precaution of keeping someone constantly near her, to sing or play on instruments, or to jest and otherwise amuse her, to the end that she might continue cheerful, and so that her face might not exhibit the melancholy expression often imparted by painters to the likenesses they take.'

I t is on the evidence of this text that the painting has come to be known as *La Joconde* in France and *Mona Lisa* (with a single *n*) in the English-speaking world. The Italian title carries an additional meaning: *giocondare* means 'to amuse or enjoy oneself' in Italian and *La Gioconda* is thus 'the woman who amuses herself'.

Is this at our expense? Vasari unfortunately wrote only from hearsay of a picture he had never seen and what he said was contradicted by two early written accounts. The first, of unknown authorship, stated that Leonardo painted a portrait of Messire Giocondo, not his wife. The second, by a first-hand witness, the cardinal of Aragon who met Leonardo in 1517, mentioned a portrait of 'a Florentine lady, painted *au naturel* on the order of the late Giuliano de' Medici'. At the end of the 16th century, the blind painter and art theoretician Lomazzo further complicated matters by pointing to a Neapolitan model and mentioning two 'springtime' paintings that

marvellously rendered 'the mouth as it smiled'. The first royal inventories referred either to a courtesan in a 'gauze veil' or to a 'virtuous Italian lady'. Could there in fact have been two *Mona Lisas*?

efforts have been made to confirm Vasari's identification. There is clear record of a Lisa di Gherardini in the archives of Florence. Born in 1479, she married Francesco del Giocondo, a widowed merchant; she set up house with him in the Santa Maria Novella district, and lost a child at a young age. A fine black chiffon covers Mona Lisa's hair; might the 'gauze veil' be mourning apparel? And might this also explain why jesters, musicians and singers were deputized to distract the model from her melancholy?

The trail comes to a further stumbling block: if Leonardo was indeed commissioned by Francesco del Giocondo, why did he not deliver the portrait, but instead keep it for years and take it with him to France at the end of his life? A Renaissance artist did not seize his brush as the inspiration took him. Before setting to work, he would agree a contract, often in the presence of a notary. If he failed to deliver, or the picture did not conform to his patron's tastes, the matter went before judges; cases of this sort punctuated the course of Leonardo's life. Vasari mentioned an unfinished work. If the Louvre masterpiece had not been finished, this could have been an initial reason for its non-delivery. However, if the source of the commission was Giuliano de' Medici there is another possible explanation: this son of Lorenzo de' Medici, Pope Leo X's brother, was a great ladies' man, as well as Leonardo's patron, and could

well have asked the artist to paint the portrait of one of his favourites. In which case, the *Mona Lisa* might be a certain Pacifica Brandano or a 'Signora Gualanda'. In 1515 Giuliano married Philiberte de Savoie and abandoned his dissolute life, but unhappily died the following year. There, at all events, are two plausible reasons why the delivery of the portrait might have been refused. What we do know is that the painter kept it and took it to France in 1516 or 1517.

another fact contests Vasari's proposition. When he painted the *Mona Lisa*, whether this was around 1504, the traditionally accepted date, or towards 1514, as claimed by a growing number of historians, Leonardo, whose fame had spread beyond the borders of Italy, was no longer undertaking portraits for society. When the Marchioness of Mantua, Isabella d'Este, called for her own promised portrait, an intermediary wrote to tell her that the artist was 'overtaxed by the brush'. He was taken up with other ideas: mathematics and engineering works. The king, Louis XII, wanted him to paint a Virgin. Leonardo prevaricated: painting no longer interested him. Yet this was not entirely true, for he went on to produce, after *The Virgin and Child with St Anne* and the *Battle of Anghiari* (a lost work), a *Leda* (also lost), the *Mona Lisa* and *St John the Baptist*. It nevertheless seems unlikely that he would repeatedly have refused commissions from a king and princess only to accept one from the silk merchant Francesco del Giocondo, even if the latter was a notable Florentine figure, and then devote four years to the portrait, if Vasari is to be believed. Favouring the hypothesis of a prestigious commission,

historians have put forward other names: a mistress of Charles d'Amboise, governor of Milan, has been mentioned; it has also been suggested that Leonardo finally yielded to the insistence of the Marchioness of Mantua; yet another candidate was the beautiful Constanza d'Avalos, Duchess of Francavilla, on the evidence of a contemporary poem referring to the portrait that 'He-who-conquers-himself' (a play in Italian on the name Vinci) painted of this lady in widow's garb, 'under the fine black veil'. However, the lady's age does not appear to fit the theory as in 1504 the Duchess of Francavilla was over forty. More recent speculations have bordered on the extravagant. The *Mona Lisa* is said to have been a boy – cut her hair and discover a ravishing young man – or a portrait of Leonardo himself. With the help of a computer, an American has superimposed the portrait of the *Mona Lisa* on to Leonardo's self-portrait in Turin: the features match. There is certainly something of a family resemblance, but this is true of the majority of his works and Leonardo himself has left another explanation: 'The painter who has coarse hands depicts similar ones in his paintings. Every characteristic that is in you, good or bad, will likewise reappear in your personae.' And again: 'Physical types often resemble their author.' Flaubert expressed the same idea another way: 'Madame Bovary is myself!'

this resemblance has generated psychoanalysis: according to Freud, in the Signora Gioconda's smile, Leonardo found a reminiscence of childhood and something of 'his mother's excess of tenderness'. There we have another explanation of the many years that he devoted to the picture and of the fact that he

did not part from it until his death. More seriously, it has been argued that the *Mona Lisa* is no more a portrait than are *St John the Baptist* or the *Virgin of the Rocks*: it is a philosophical poem, an allegory, the very symbol of womanhood, a pictorial formulation of the feminine archetype. Here again the computer has supported the theory: the superposition of thousands of photographs of feminine faces of every variety has produced a generic, softly defined image not unakin to the *Mona Lisa*. Nevertheless, even if transcending the usual characteristics of the genre, the *Mona Lisa* remains incontestably a portrait. The argument, which is fairly persuasive, seems more applicable to that painting misleadingly referred to as the '*Naked Mona Lisa*', which represents a smiling woman with a sturdy throat and hands crossed on a little wall. Many versions, often featuring a floral background, are in existence, the best being the cartoon in Chantilly. Could one of these *Floras* or *Primaveras* (entitled the *Mona Vanna*, to avoid confusion with its famous rival) be the second 'springtime' *Mona Lisa* mentioned by Lomazzo?

but if there are two *Mona Lisa*s, could the latter not be the mistress of the libertine Giuliano de' Medici painted *au naturel*, whose portrait the cardinal of Aragon saw in Blois one August day in 1517? '*Au naturel*' can mean either 'realistically' or 'undressed'. Be this as it may, none of the various paintings of the '*Naked Mona Lisa*' appear to be by Leonardo's hand. They are the work of his disciples or followers after a drawing by the master: to Leonardo, painting was above all a 'cerebral thing'; he was content to produce a sketch that fully expressed his idea and leave the final execution, a subordinate task, to others,

whose names have not in every case come down to us. When the cardinal of Aragon paid Leonardo a visit two years before his death, the latter showed him the best of his production: he would not have presented the work of his assistants to the prelate, a great connoisseur of the arts.

I dentification of the model would be a purely anecdotal matter did it not touch on the question of date. Before 1504? *Circa* 1514? A drawing by Raphael depicting a young woman with her arms resting on a balcony in the pose of the *Mona Lisa* argues in favour of the earlier date. Raphael could have seen Leonardo's masterpiece in Florence, copied it and then repeated the formula of the turning figure with crossed hands. Leonardo defined the underlying principle of the pose thus: 'Always make your figures so that the direction of the head is not the same as that of the chest.' This formula, completed by the smile, gives an impression of intimacy, simplicity and monumentality all at once. A significant invention, it was to be adopted by a great many artists; in the 19th century, for example, Corot used it in his *Woman with a Pearl*. But was it truly such a novelty for Leonardo? His presentation of the hands was perhaps inspired by the *Bust of a Young Woman*, the work of his master, the aptly named Verrocchio ('true eye'), whose *David* anticipated the same torsion of the bust and the smile. If in the *Mona Lisa* Leonardo carried the formula to heights of perfection, it was clearly something he had developed over the years: the portrait of Ginevra Benci (its hands now amputated), the *Lady with an Ermine* and the cartoon of Isabella d'Este trace the progress of his researches. And there were no doubt other sketches

which have been lost, so it is not unthinkable that Raphael came across the innovatory formula without seeing the *Mona Lisa* itself. The resemblance between Raphael's sketch and Leonardo's painting is not in any event limited to the pose: behind the young woman, two columns frame the landscape. While the flat scenery is not very Leonardesque, the columns directly echo those originally found in the *Mona Lisa* – although now no more than an edge and the suggestion of a base can be seen in the painting in the Louvre. Like so many of Leonardo's works, the *Mona Lisa* has suffered both from the ravages of time and from rough treatment by restorers: it has been narrowed by six or seven centimetres on both the right and left.

t he columns clearly existed, however, and are to be seen in several old copies. Moreover, the middle ground, which adds depth to the landscape, seems never to have been used before in such radical form by Leonardo. Does Raphael's sketch, the dating of which is more or less certain, not establish the date of the *Mona Lisa* once and for all? But exactly what would Raphael have seen? Probably not a completed work. In 1499, with the Sforzas in flight, Leonardo left Milan where he had spent seventeen years; in 1500 he was in Mantua, from where he went to Venice and Florence, where the monks of the Annunziata commissioned him to paint a *Virgin and Child with St Anne*; in 1501 he immersed himself in the study of mathematics; in 1502 he took part, as a military engineer, in the campaign on the Romagna under the orders of Cesare Borgia; in 1503 he was involved in a project to divert the Arno and worked on the *Battle of Anghiari*; in 1504, the

year of his father's death, he was again engaged on fortifications, at Piombino, and on hydraulic schemes; in 1505 he resumed his project for a flying machine. If he had already made a start on the *Mona Lisa*, he could not have had much time to take it further. Raphael would thus have seen no more than the first sketch or the cartoon, in other words the finalized composition ready to be transferred on to a wooden panel, which would account for the differences between his sketch and the work in the Louvre. All would have been much simpler had Leonardo conserved the least note or drawing that could be linked to this painting. The majority of his works have some counterpart in his manuscripts: the sketches that have survived, for example, enable one to trace the line of thought that culminated in the *Adoration of the Magi* and the *Last Supper*. But there is nothing that refers to the *Mona Lisa*, which seems to have emerged from a vacuum. Not a sketch, not a word, relates to the picture. Her smile guards its secret. Roughly a third of Leonardo's notebooks have come down to us. Two of them were miraculously rediscovered in 1965 in the labyrinths of the National Library in Madrid; they have proved a treasure house of information on the giant horse that Leonardo sculpted in Milan in around 1490. Might others also reappear, and elucidate finally the mysteries of the *Mona Lisa*?

r elying once again on the computer, it has recently been claimed that a necklace originally adorned Mona Lisa's neck and that the artist removed it when he returned to the painting in 1513. Other theories are that Mona Lisa was pregnant and that her smile masked a toothache. Seeking to reconcile

Vasari's account with that of the cardinal of Aragon, some have also argued that Mona Lisa was an unfaithful wife and that she was one of Giuliano de' Medici's mistresses. Another method of dating has been provided by laboratory analysis. Radiography has revealed a very distinctive artistic technique: to blend his different tones, Leonardo superposed glazes so light that the X-rays passed through them virtually unobstructed by the pictorial material. In the final analysis, instead of the expected contrasts, one can only see nebulous waves through which the fibres of the wooden support emerge most distinctly. The atomic weight of the colours used is infinitesimally small. The pigments float in a very fluid medium, as in the work of Van Eyck, so that light is refracted by the white ground. Hence comes an extraordinary luminosity, even in the shadows, and with it a mirror-like surface (at the outset) that seems to assimilate the line of the brush. This distinctive technique, a prerequisite of the *sfumato* effects, called for an unparalleled dexterity. The efforts that have been made to copy the *Mona Lisa* are partly due to the fact that Leonardo's craft seemed inimitable. It demanded infinite application and patience: a multiplication of fine layers with no reworking, allowing each one the time to dry. The softness and delicacy of the resulting modelling presented a form of challenge to future generations, an impossible *tour de force*. No copy, not even the oldest, has succeeded in exactly re-creating either the look or the smile, which are distorted and weighed down by the slightest divergence.

The X-rays of *The Virgin and Child with St Anne* reveal a technique that is even lighter. And those of *St John the Baptist*, the artist's last work, are of such minimal density as to be almost transparent: the laboratory in the Louvre has stopped reproducing them. This progression towards an increasingly fine *matière* throws light on the chronology of his works, specifically the order of their execution:

the *Mona Lisa* thus precedes *The Virgin and Child with St Anne*, which in turn precedes *St John the Baptist*. It remains to establish when *The Virgin and Child with St Anne* was painted. The cartoon in the National Gallery, London, can be dated 1500, the time of the Sforzas.

but the painting? The date of 1505 has been moved forward, as have those of 1508 and 1510, a period when Leonardo divided his time between Florence and Milan. This theory does not entirely rule out the possibility that the model was a mistress of Giuliano de' Medici, as we do not know when Leonardo made the latter's acquaintance, but it brings the execution of the work to an earlier date than that favoured by current thinking. Vasari was not always wrong; he based his information on reports emanating from Florentine workshops. It is easy to imagine, from what he has recorded, that Leonardo started the painting in Florence in about 1504; that, admirable as it was, the picture remained unfinished at the end of four years; and that he completed it elsewhere, in Lombardy, perhaps in the Adda valley, where his young protégé Francesco Melzi owned a house. Leonardo paid several visits there: the composite and idealized landscape taken to the point of perfection in the *Mona Lisa* is more akin to the foothills of the Alps than to the slopes of Tuscany. It is a twilight scenery with a chaos of peaks, serpentine valleys and rushing torrents; a three-arched bridge on the right spans intractable waters. This wild and unbounded nature, devoid of all human presence, is set in opposition to the smile and the calmly crossed hands as much as to the symmetrical columns that enclose the composition. On one

side is the polished, civilized world; on the other, brute forces at once terrifying and fascinating. The opposition of the two is nevertheless made without clash: Mona Lisa fits perfectly into her surroundings, which seem to express all that is masked by her sibylline smile.

1

eonardo was a theatrical man. Chroniclers have recorded the sensation caused by his staging of the *Dance of the Planets* in 1490. A master of illusion, he conceived the false perspective of the *Last Supper* in the manner of a stage décor. He had a great appreciation of the effects of opposition: the smile of a pretty woman veiled in black; a serene attitude against a desolate background; a benevolent gaze answering a wilderness of jagged rocks. As day fades behind her, Mona Lisa gazes on us from her stone box, a stage within a stage. Contrary to what has often been asserted, her smile was not new to Leonardo's work. Its outlines were already emerging in *Lady with an Ermine* and *Virgin of the Rocks*. Once again, the *invenzione* did not spring up *ex abrupto*; it matured slowly before being brought to its peak. From picture to picture, the smile takes shape, finally reaching its pinnacle in the *Mona Lisa*, in order to become a 'Da Vinci speciality': St Anne and Leda smile in the same way, and the last *St John the Baptist* very effectively combines the smile and the index finger pointed towards heaven, another 'speciality' of the master. The clowns and musicians introduced by Vasari probably had a basis in fact: Leonardo directed the expression of his figures as he determined their gestures and the décors. He had never seen the model quite in the way that he presented her; this is not a portrait of a woman captured in a familiar

attitude in the manner of the centuries to follow. What Leonardo gives us here is, above all, the fruit of his years of study of the mechanisms of the human expression (*i moti*); in this sense the *Mona Lisa* is a fiction, *una finzione*: according to Leonardo, the painter, like the poet, must compose 'fictions that express great things'.

The light and the atmosphere, which are the unifying elements of his composition, owed nothing to chance. 'Observe when evening falls in the street in bad weather,' he wrote, 'what delicacy and grace are to be seen on the faces of men and women.' Elsewhere he acclaimed the merits of clouds, of fog, of those deep streets where even at midday 'cheeks reflect only the darkness that surrounds them', and where the shadows, 'freed from excessively hard contours, harmoniously fade out.... You will have then, O painter, a specially fitted courtyard, with walls painted black, and a roof projecting over these walls; this courtyard will be ten arms'-lengths wide and twenty long and ten high; and, when it is sunny, you will take care to cover it with a cloth.' Could it have been in a studio of this kind that he made his model pose, so that only the front of her face was lit, like all his other figures, by the gentle light of an artificial evening?

●

In the final reckoning, the portrait seems to be but a pretext. Whatever the identity of the person we call Mona Lisa, Leonardo, trained in the neo-platonic Florence of Marsilio Ficino, cast her in the mould of his own preoccupations and raised her to the heights of the universal. Devising a kind of Bertillon system in advance of its day, he analysed facial characteristics one by one; he noted the play of muscles produced by movements and

expressions; he dissected corpses, excavating them to the heart, the 'core from which grows the tree of veins'. In one youthful memorandum he set out to 'state what the soul is'; it was a quest he never quite abandoned, even if he did not find the answer with his scalpel. Putting his astonishing virtuosity to the exploration of every register of the human physiognomy, he sought to show the soul's reflection with his brush and colours. The sphinx may present its riddle in a thousand and one ways, but the answer remains the same: the human being – that is the response to be made by the traveller under threat of being devoured. The *Mona Lisa* portrays the mystery of life; put differently, the mysteries deliberately orchestrated by Leonardo operate above all as a metaphor. In this sense the *Mona Lisa* is a masterly demonstration of what painting should be. The details of its history are ultimately of little consequence – that Leonardo gave, sold or bequeathed the picture to Francis I; that it was Melzi, the executor of his will, who handled the negotiation; that the painting was bought for the inordinate sum of four thousand gold écus, as reported by Father Dan who was at the time in charge of the inventory of the royal treasures. Nor does it matter if it was put in Versailles by Louis XIV and taken by Napoleon to his bedroom in the Tuileries or that there are over sixty old copies of the work in museums and private collections. All this adds nothing to the emotion produced by the painting, or to its central place at the very core of the history of art.

t he theft of the *Mona Lisa* on 21 August 1911 by the house painter Vincenzo Peruggia, its sensational return two years later and the prolific literature generated by the picture

since the 19th century have done nothing to diminish its fame. The painting was clearly intended from the outset to cause a sensation, to be a 'fiction that expresses great things'. A generator of emotion, it has provoked aggression and vandalism. A custodian at the Louvre fell in love with it and lost his mind. The hoards of tourists who today file past its armoured glass case have given rise, with a certain inevitability, to the term *'jocondolâtrie'*, another part of the myth. Some admire, some feign admiration; and there are those who think it more fashionable to disparage. But are we still really able to see the *Mona Lisa*? Since Marcel Duchamp defaced her in 1919 by adding moustaches and a goatee beard with the caption *L.H.O.O.Q.*, artists have made free use of her image in their works. Malevich, Léger, Dalí, Warhol and many more have each in turn striven to 'desacralize' her. The term does not seem to me apt. Duchamp said to his friend Roché: 'Do not let yourself be hypnotized by yesterday's smiles, invent rather those of today.' The inventor of the 'ready-made' had no particular objection to the *Mona Lisa*. It was rather that she alone struck him as worthy of representing the cultural heritage from which he wished to break away. Painters are the best judges in the matter of art; what they say in their different tributes is that the *Mona Lisa* is the painting of all paintings; if you can only keep one, choose that one; it is more than a painting, it is painting itself.

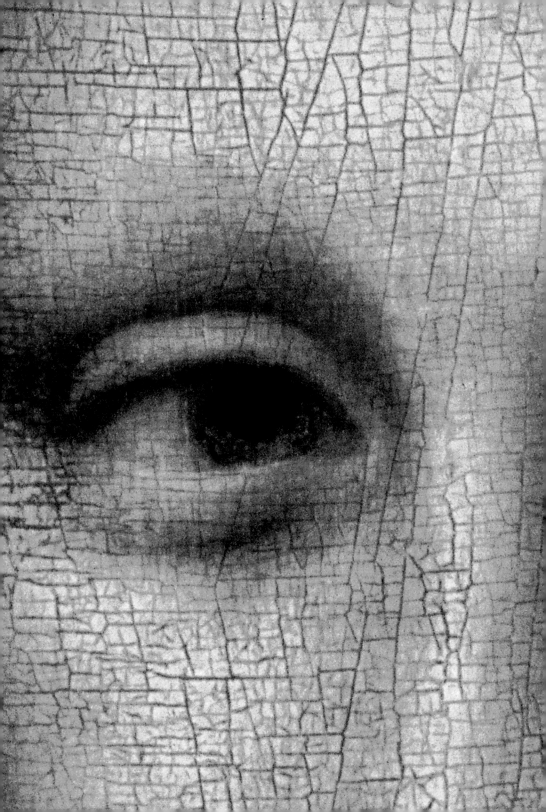

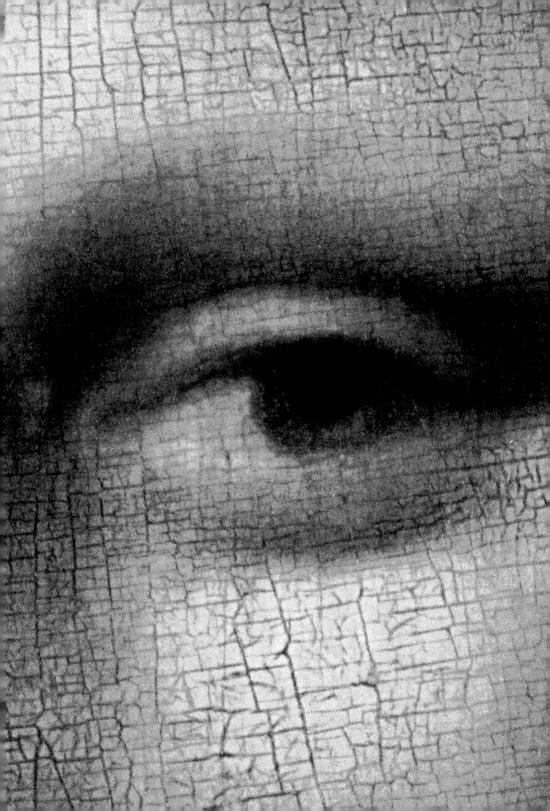

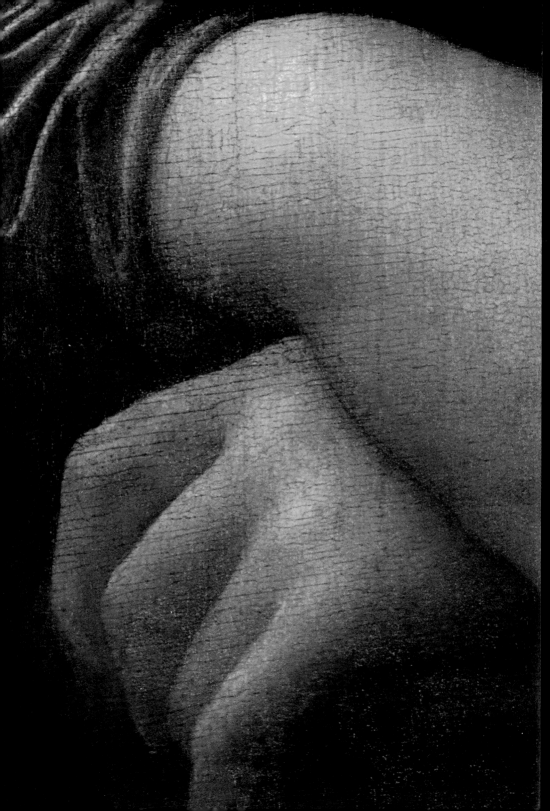

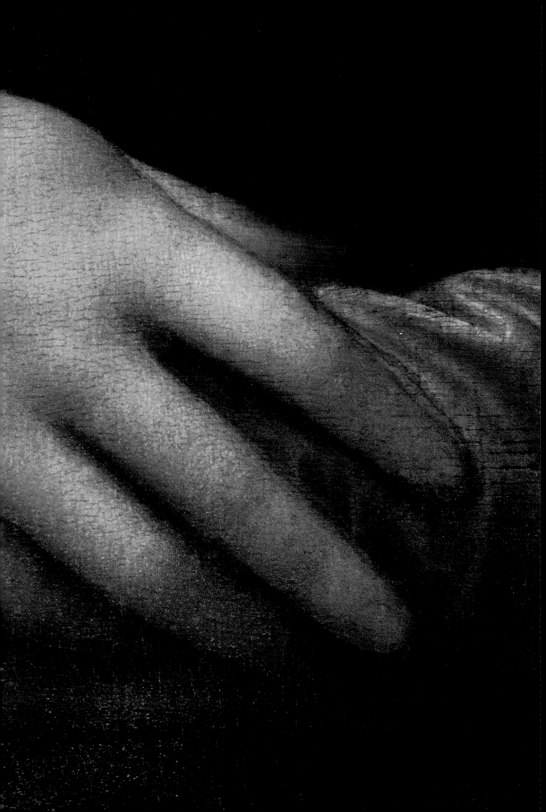

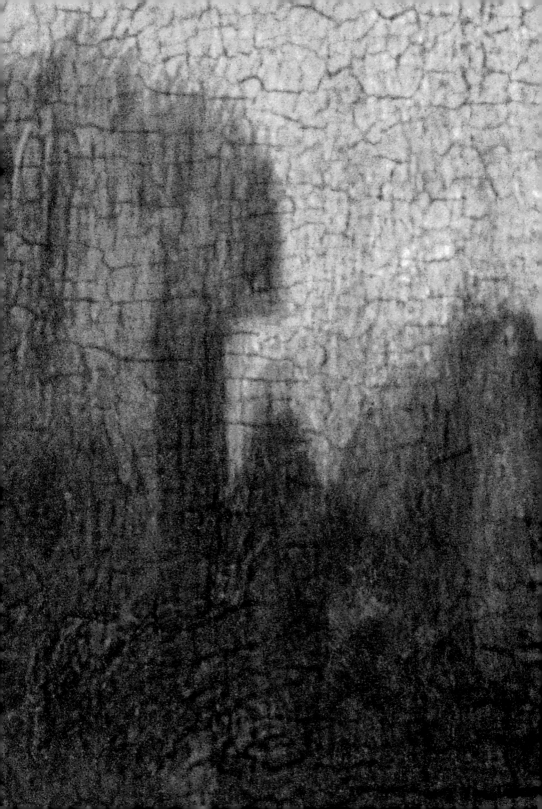

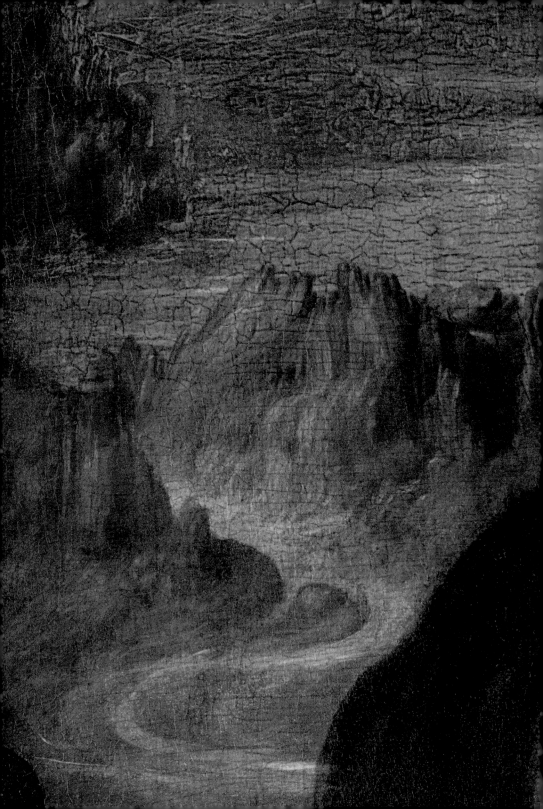

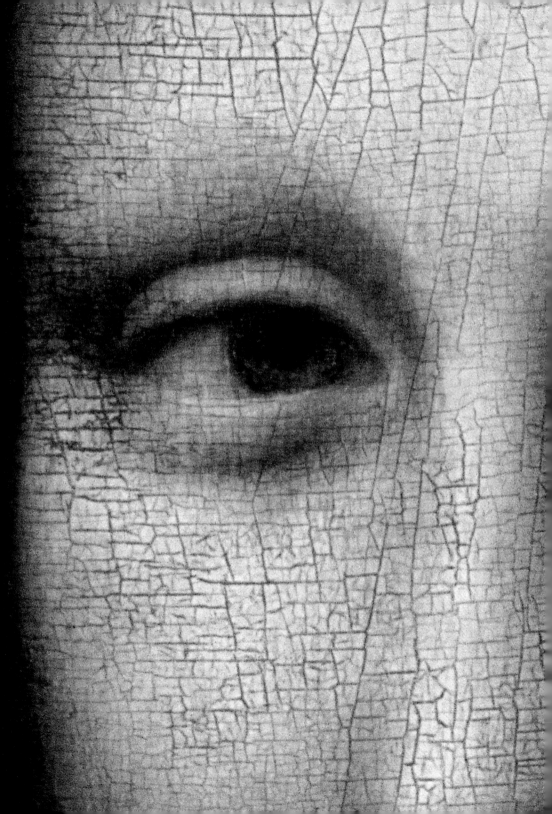

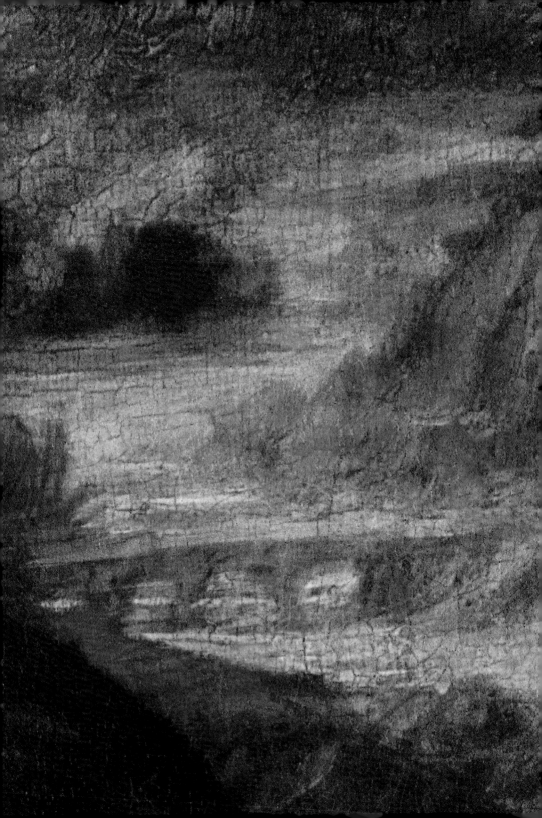

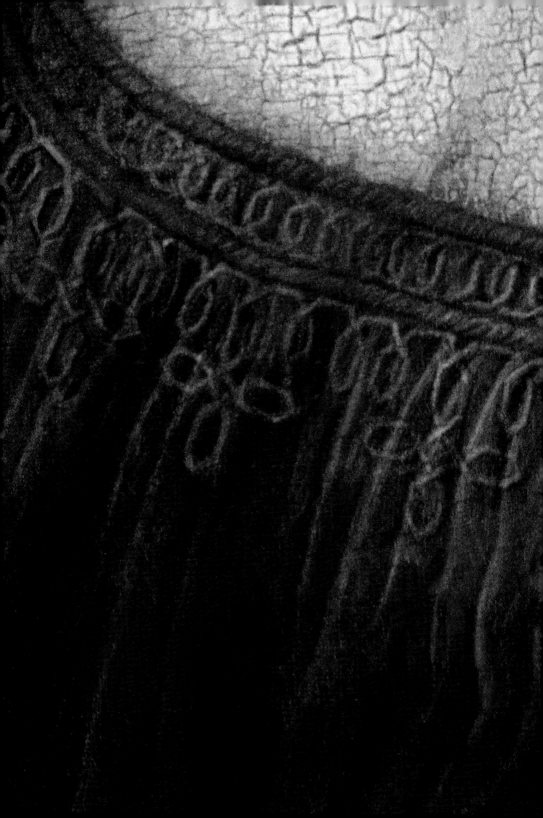

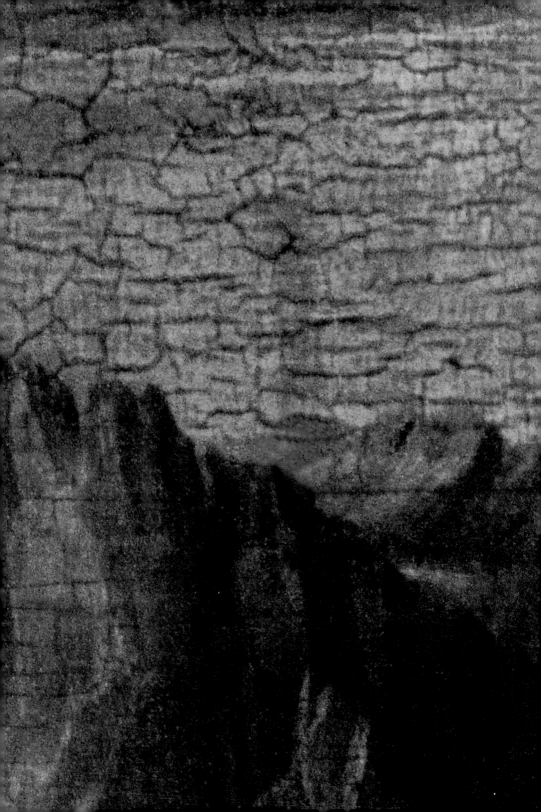

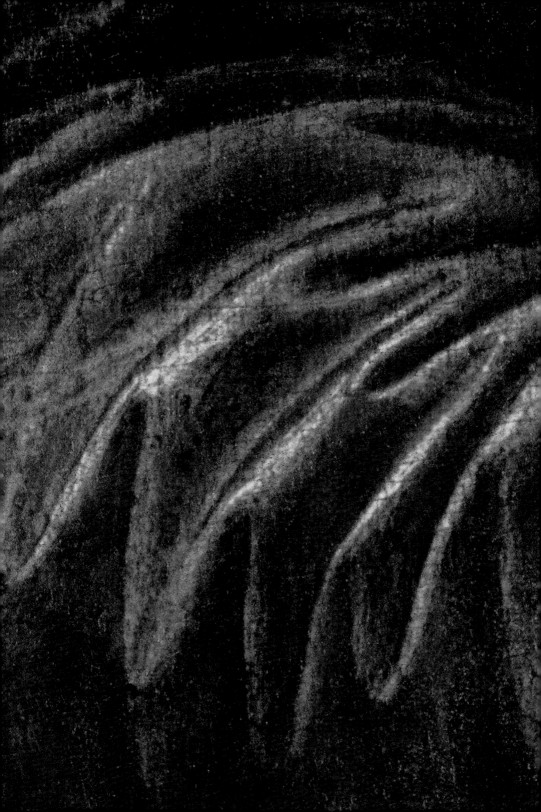

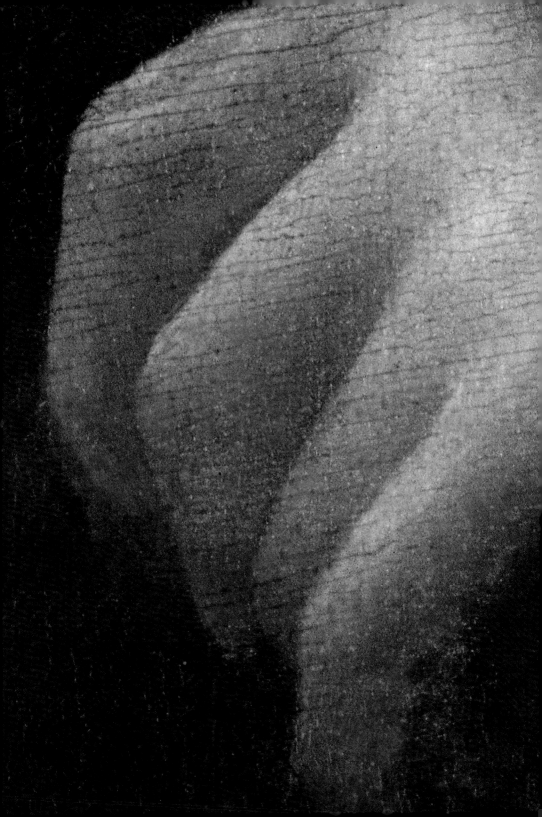

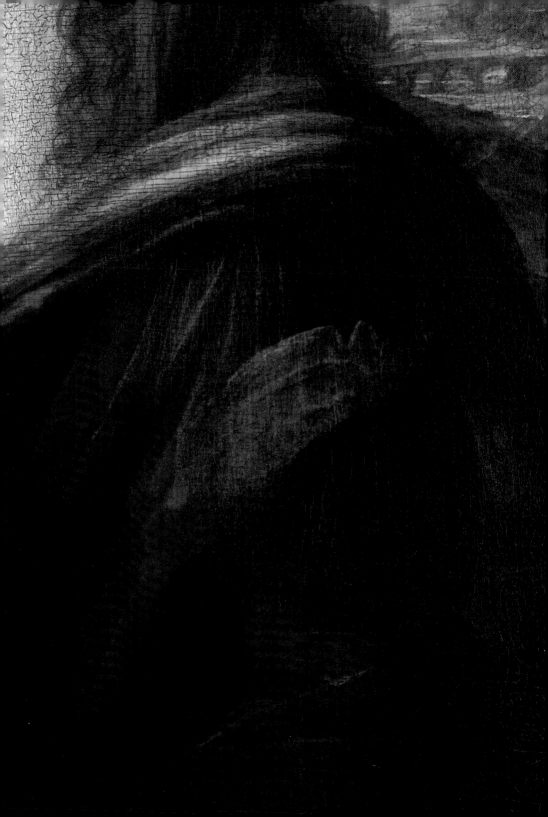

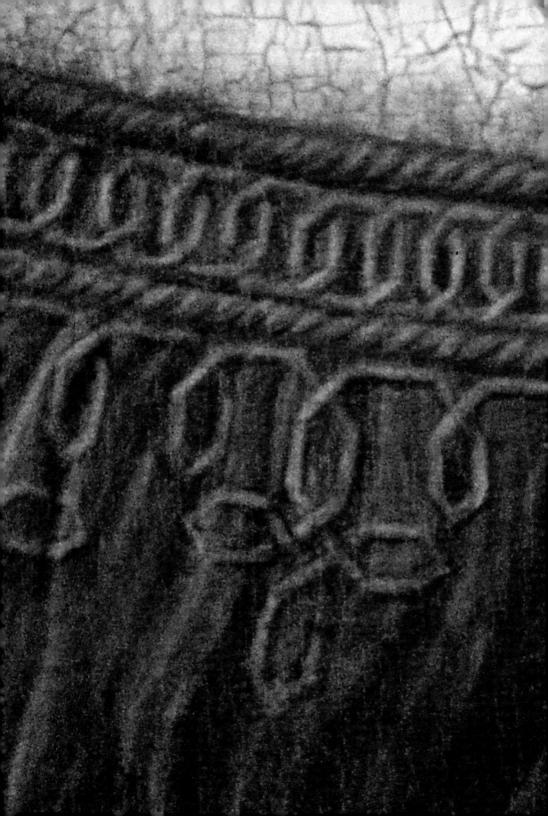

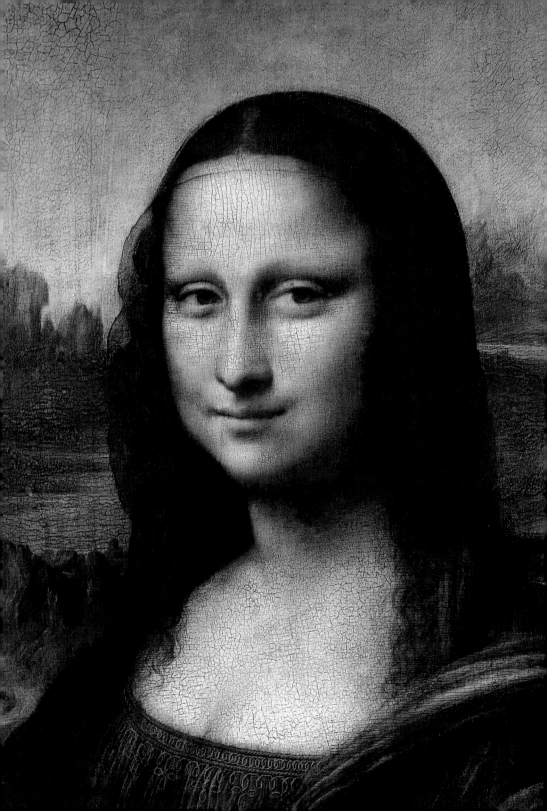

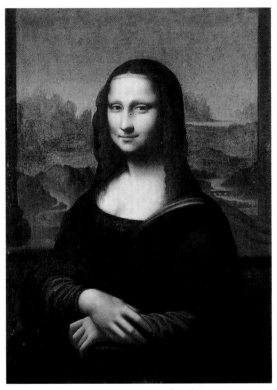

Anonymous, *Mona Lisa with Columns*.

Opposite: Raphael, *Half-Length Portrait of a Woman*.
Following pages: After Leonardo da Vinci, *Naked Mona Lisa*.
Leonardo da Vinci, *Portrait of Isabella d'Este*.

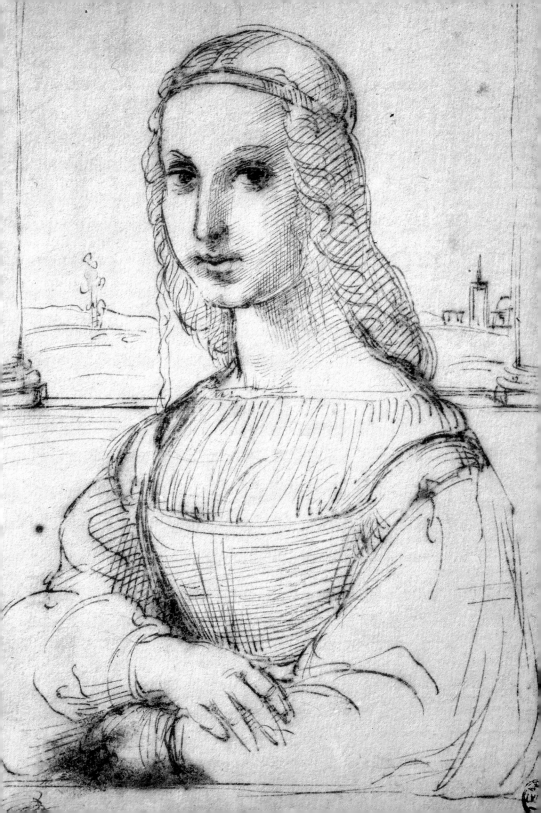

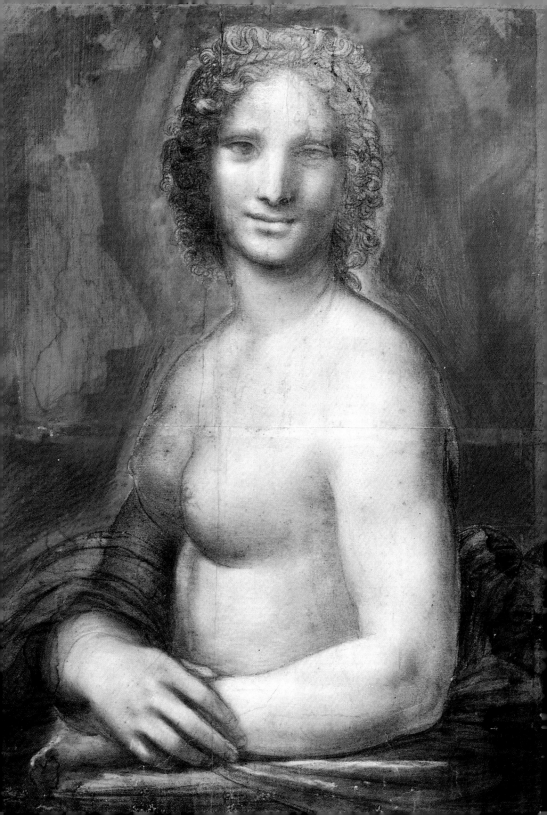

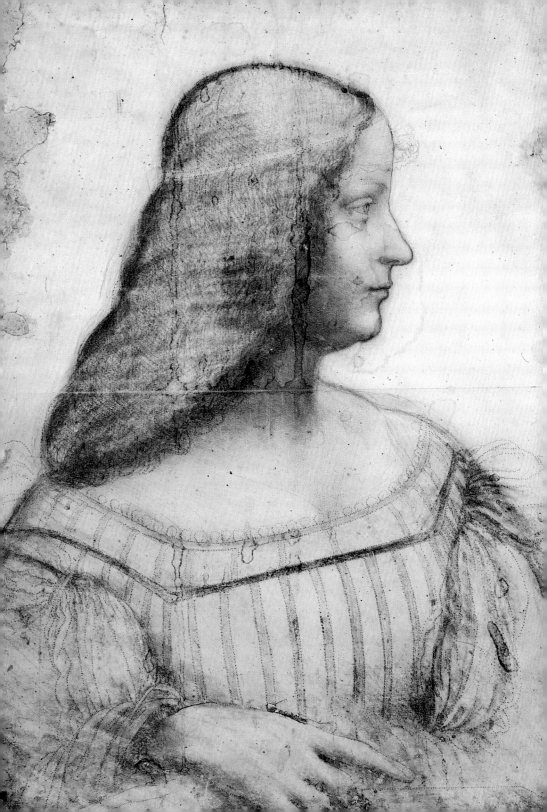

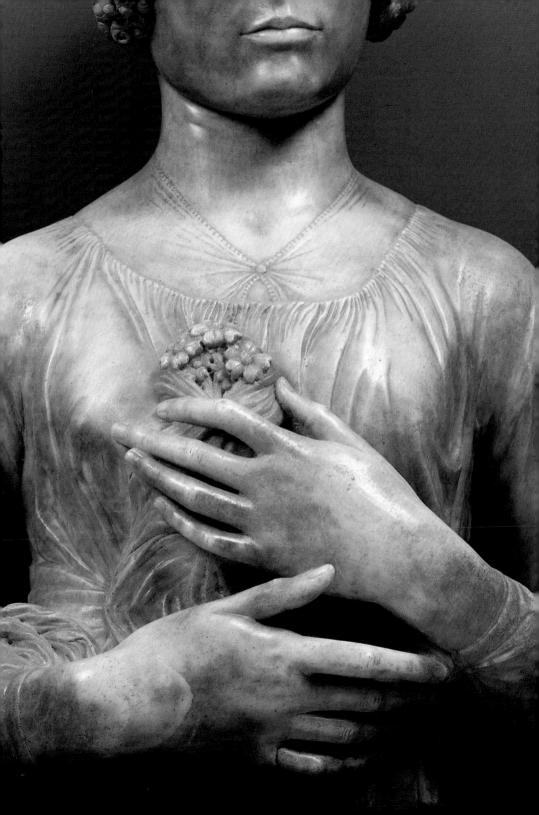

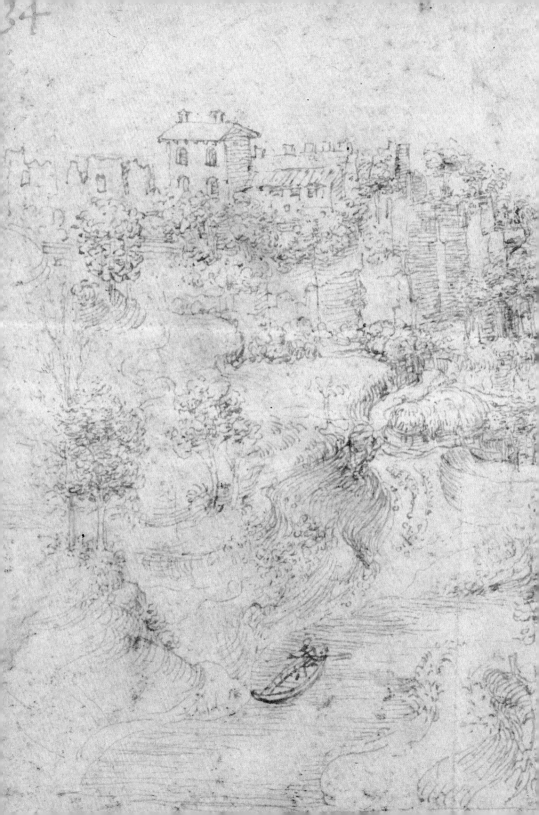

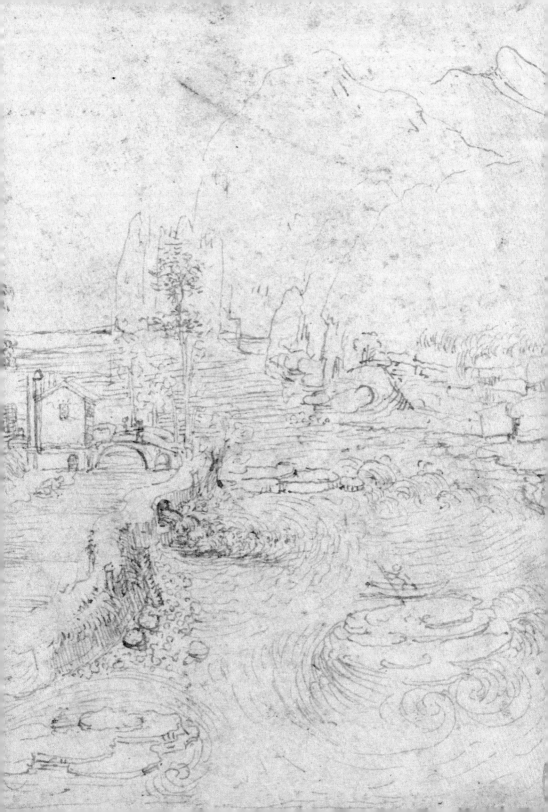

The beginnings of fame

although the eighteenth century discovered Leonardo's caricatures, due in large part to Pierre-Jean Mariette's engravings of 1770, it does not seem that the *Mona Lisa* exerted any great fascination over the age. Neither Diderot nor the Comte de Caylus mentions the painting. Even in 1817, Stendhal merely remarks on the absence of eyebrows and notes that 'the right hand is lit absolutely in the manner of Correggio'. The fame of the work only really begins in 1830. Suddenly it began to be extensively reproduced. Théophile Gautier, earlier than Walter Pater, speaks of a 'singular, almost magical, charm'. The first attempts to reproduce the *Mona Lisa* – lithographs by Aubry-Lecomte and Collette – proved, however, to be unsatisfactory. The subtleties of the *sfumato* seem to have been particularly difficult to render. For the printmaker, even more than for the painter, Leonardo's technique contains something quite inimitable. When he undertook to engrave the work on copper, Luigi Calamatta practically had to reinvent his art. An article in the *Gazette des Beaux Arts* of 1859 gives an account of the task: 'M. Calamatta employed a system of broken engraved lines combined with dots and accompanied … by a series of small intermediate lines which produce darker areas…. Here the engraver is returning to the lozenge method, as practised by the Italians, who called it *mandorla* (almond); but there is this difference, that in Calamatta's engraving, to achieve greater delicacy, the lozenge is formed by the diagonal crossing of a broken line over the first incision….' It took Calamatta twenty years to complete his reproduction, and, by his own admission, he still did not succeed in conveying all the painting's subtleties.

The famous engraving by Calamatta, 1859.

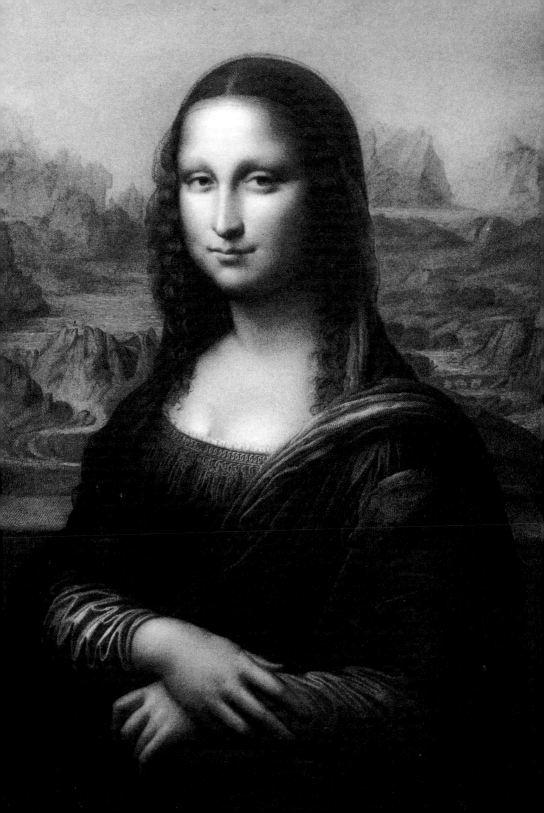

Museology

t he *Mona Lisa* is listed in the inventory of the Louvre as number 779 and in the catalogue as number 1601. It measures 76.96 cms in length by 53.08 in width; the missing strips at the side, which originally depicted the columns framing the picture, are estimated at 7 cms each. Like all Leonardo's works, the painting is unsigned, undated and untitled. It was executed in oil with fine brushstrokes on a panel of white Lombardy poplar, the back of which is lacking in a crosspiece or other support. The panel has a slight vertical split in the upper left part. The pictorial surface adheres to a fine preparation of the *gesso duro* type.

The overall state of conservation of the paint is reasonably satisfactory. But if old descriptions are to be believed, the *Mona Lisa* has not always appeared as she does today. Vasari, for instance, wrote that around her lustrous eyes were 'those pale, red, and slightly limpid circles, also proper to nature, with the lashes, which can only be copied, as these are, with the greatest difficulty. The eyebrows also are represented with the closest exactitude, where fuller and where more thinly set, with the separate hairs delineated as they issue from the skin.... The nose, with its beautiful and delicately roseate nostrils, might be easily believed to be alive. The mouth, admirable in its outline, has the lips uniting the rose-tints of their colour with that of the face, in the utmost perfection, and the carnation of the cheek does not appear to be painted, but truly of flesh and blood. He who looks earnestly at the pit of the throat cannot but believe that he sees the beating of the pulses.'

This is a second-hand description, it must be remembered, and

It is in the light-coloured flesh areas that the paint has been most affected. Here the *craquelures* are naturally wider, while they are narrower in the darker areas.

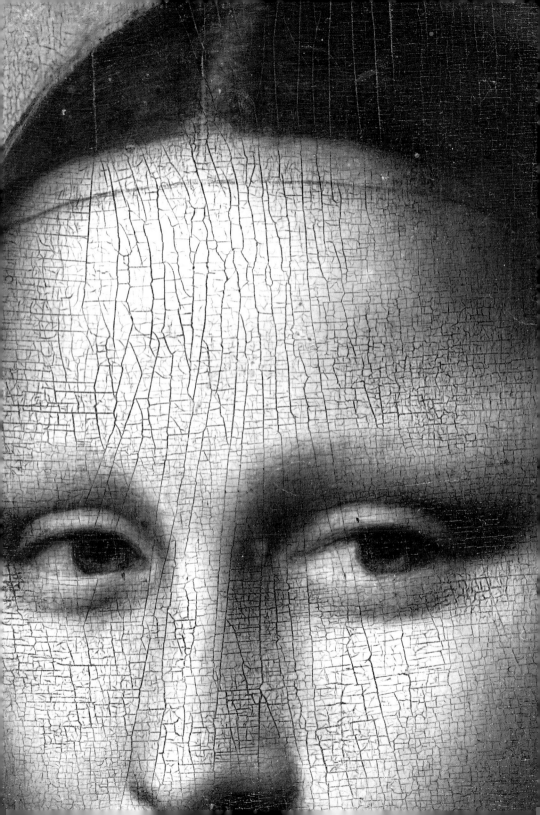

questionable in many respects, but nonetheless it raises the question of the painting's original appearance. To what extent have the pigments and medium altered with time? Was the *Mona Lisa* originally more highly coloured? Have details such as the rosiness of the cheeks, the eyelashes and the eyebrows suffered from over-zealous cleaning in the past? Leonardo painted in successive layers of glaze and the restorers of earlier centuries could well have removed the top layers, mistaking them for varnish. The upper eyelids, for example, bear the shadow of unseen lashes. But the eyebrows? It was fashionable to pluck them in Florence at the period and old copies of the *Mona Lisa*, with the exception of that conserved in the Prado (one of the least faithful), are also lacking in them. As for the colour, inevitably darkened and yellowed by the passage of time, it is not necessarily as altered as has often been supposed. Leonardo in his notebooks professed his distaste for a 'certain race of painters whom lack of understanding compels to take gold and blue as the model of beauty'. He above all favoured the almost monochrome light of overcast and evening skies. The blue of the distances has probably oxidized; Mona Lisa's skin must once have had a fresher gleam; the colour of her clothing, if not actually purer, would at least have been more differentiated; however, it seems unlikely that the original *Mona Lisa* radically differed from that of today as has happened with the frescoes in the Sistine Chapel before and after restoration. What restorer would now risk touching the *Mona Lisa*? But what none would dare attempt with the original, a researcher at the University of California, J.F. Asmus, has done on computer with the help of Professor Pedretti. Working on a digital image, he has tried to correct the colours and conceal the *craquelure*. The painting has emerged rejuvenated. It would be difficult to go further than this without risk of error.

Computer restoration by J.F. Asmus with the help of Professor Pedretti, California.

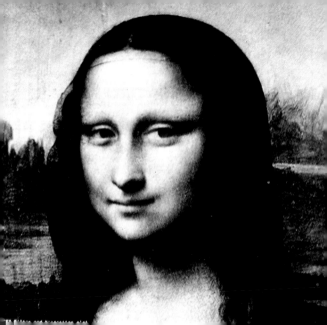

Leonardo and the smile

Virgin of the Rocks

Mona Lisa

St John the Baptist

La Belle Ferronnière

Mona Lisa, it has been said, smiles only on one side, or at least only half smiles. This slight dissymmetry accentuates the impression that the smile is not directed straight at the spectator; it seems to slip away, refusing interpretation. It expresses neither happiness nor seduction. Nor is it the mystic appeal of a saint or of the Virgin. How therefore should the smile be understood? Above all, as a deliberate enigma.

Leonardo and the look

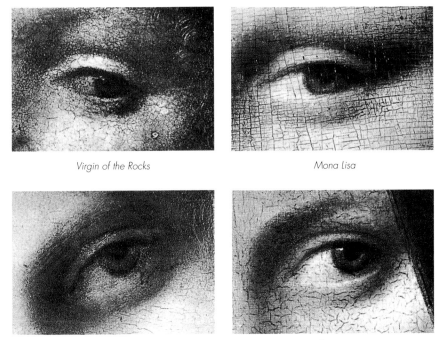

Virgin of the Rocks

Mona Lisa

St John the Baptist

La Belle Ferronnière

Sight, for Leonardo, was the most important of our senses, 'the best and the most noble'. For him the eye was an instrument of investigation that was even more reliable than the mind. 'Do you not see,' he said, 'how the eye embraces the beauty of the whole world?' While the lips express their enigma, the look scrutinizes the spectator in such a way that a two-way movement is set up, like a game of questions and answers.

Leonardo and the hands

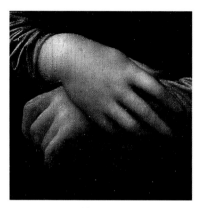

Mona Lisa

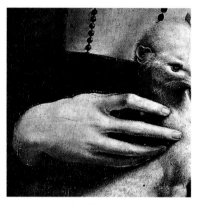

Lady with an Ermine

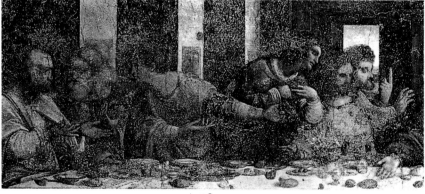

Last Supper

From as early as the *Adoration of the Magi* or his first *Madonnas*, Leonardo assigned a significant role to the hands of his figures, or rather to what they signified. Like those of Buddhas, the hands speak a coded language, the most striking examples being those of the *Virgin of the Rocks*, the *Last Supper* and *St John the Baptist*.

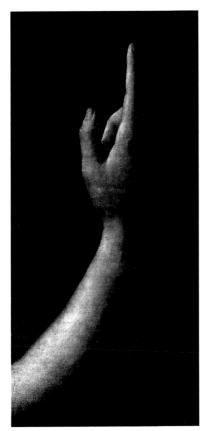

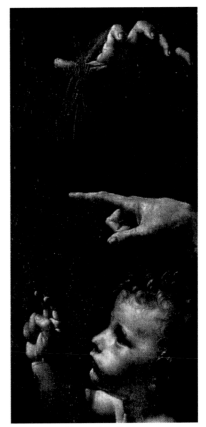

St John the Baptist _Virgin of the Rocks_

The _Mona Lisa_'s hands reveal some pentimenti, indicating the great care that the artist accorded them. Their delicate modelling has a kind of secret tension. In the same way, their apparent serenity is in opposition to the tense folds of the sleeves: the chaos of matter is answered by the shining light of the human being.

Leonardo and the landscape

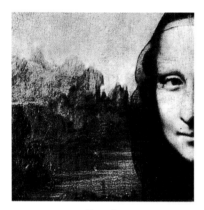

Mona Lisa

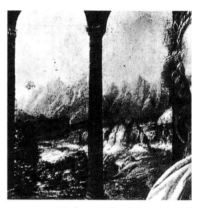

Madonna with a Pink

Annunciation

However detailed, the landscapes of the Italian Renaissance most frequently present a nature that is recomposed and deliberately symbolic. Thus rocks, much used by Leonardo, traditionally designate the desert and are the attribute of hermits.

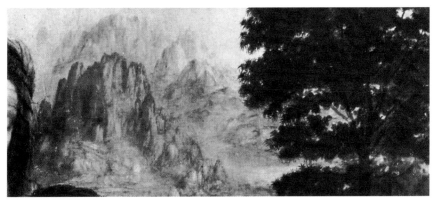

Virgin and Child with St Anne

Virgin of the Rocks

With Leonardo, however, the landscape does not only have a narrative value. Its depths open on to the universal. It complements the expressivity of the model: more than a backdrop, it is a major element in the artist's 'fiction'.

Mona Lisa desacralized

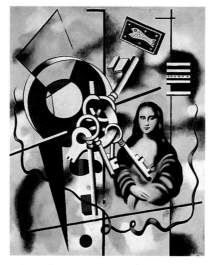

Fernand Léger, *Mona Lisa with Keys*, 1930.

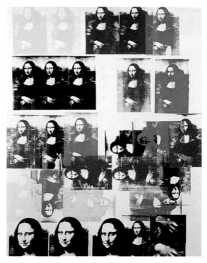

Andy Warhol, *Mona Lisa*, 1963.

Opposite: Marcel Duchamp, *L.H.O.O.Q.*, 1919.

And also: Salvador Dalí, Philippe Halsmann, Kazimir Malevich, Max Ernst, Jean Lagarrigue, Yvaral, Richard Rein, Francis Picabia, Cejar, Georges Isarlo, Siné, Wasselman, Maurice Henry...

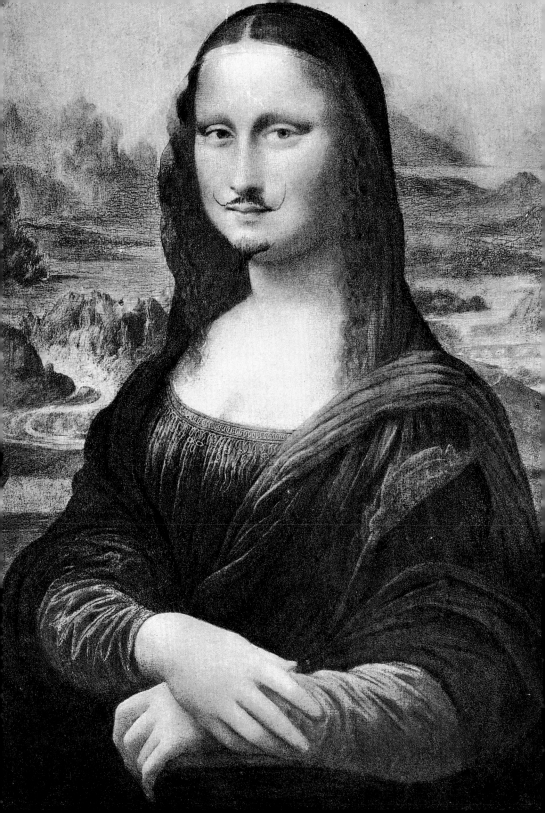

Leonardo da Vinci

1452-1519

Chronology

1452 15 April, birth of Leonardo, illegitimate son of the notary Piero d'Antonio and one Caterina, in the village of Vinci (Tuscany).

1456 Hurricane ravages Tuscany.

1469 The name of Leonardo figures in his father's tax statement, in Florence. Leonardo enters Verrocchio's studio as a pupil (exact date unknown). Death of Piero de' Medici, who is succeeded by his sons Lorenzo and Giuliano.

1472 Leonardo is enrolled in the register of the painters' guild in Florence (at the same time as Perugino and Botticelli).

1473 Verrocchio paints the *Baptism of Christ* with the help of Leonardo.

1475 Leonardo's father takes as his third wife one Marguerita, who will bear him six children. 9 April, Leonardo is accused of sodomy; nonsuit declared 16 June. Birth of Michelangelo.

1481 Leonardo receives commission for the *Adoration of the Magi*, which he left unfinished. Verrocchio works on the equestrian statue of Bartolommeo Colleoni.

1482 Leonardo settles in Milan, in the service of the Duke, Ludovico Sforza.

1483 Leonardo receives commission, jointly with the Da Predis brothers, for the *Virgin of the Rocks*. Birth of Raphael.

1485 Plague ravages Milan. Leonardo draws up plans for an ideal city. Birth of Titian.

1487 Leonardo takes part in the competition for the *tiburio* of Milan cathedral.

1489 Leonardo pursues researches in anatomy and architecture.

Opposite: A page of Leonardo's manuscript.

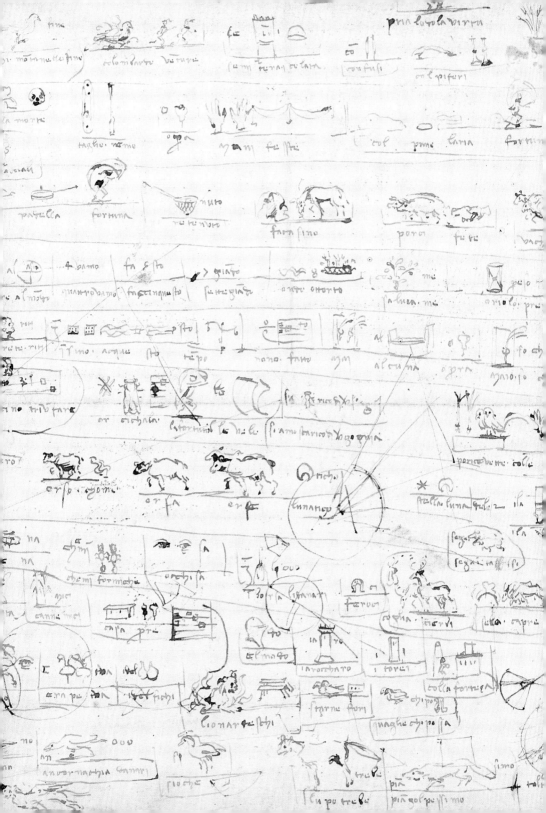

1490	Leonardo works on the equestrian monument of Francesco Sforza.
1492	Christopher Columbus discovers America. The Jews are expelled from Spain.
1494	Start of the Italian wars. Savonarola institutes the Republic of God in Florence.
1495	Leonardo works on the *Last Supper* in the refectory of Santa Maria delle Grazie.
1496	Leonardo collaborates on Luca Pacioli's *De Divina Proportione*. Stages the *Danaë*.
1498	Leonardo works on the decorations of the Sala delle Asse in the castle.
1499	Leonardo flees Milan when the city is occupied by French forces.
1500	Leonardo stays temporarily in Mantua and Venice before returning to Florence. The monks of the Church of the Annunziata commission the *Virgin and Child with St Anne*.
1501	Beginning of the slave trade to America.
1502	Leonardo appointed military engineer to the armies of Cesare Borgia. Romagna campaign and friendship with Machiavelli.
1503	Florence at war with Pisa. Leonardo begins the *Battle of Anghiari*.
1504	Death of Leonardo's father, who had married for the fourth time, leaving thirteen children. Leonardo is engaged on the fortifications of Piombino.
1505	Leonardo pursues researches on the flight of birds. Receives final payment for the *Battle of Anghiari*.
1506	Leonardo leaves Florence for Milan at the invitation of Charles d'Amboise, the French governor.
1507	Leonardo is appointed painter and engineer-in-ordinary to Louis XII. In September he returns to Florence for six months. Lawsuit with his brothers over their father's inheritance.
1508	Leonardo pursues researches in hydraulics. Plans equestrian monument of Gian Giacomo Trivulzio. Michelangelo starts work on the Sistine Chapel frescoes.

1509 Leonardo pursues researches in anatomy.

1513 Election of Pope Leo X.
 Leonardo moves to Rome. Works on mirrors.

1514 Leonardo goes to Parma and Florence. Draws up scheme for draining the
 Pontine Marshes.

1516 Death of Giuliano de' Medici, Leonardo's patron.

1517 Leonardo settles in France, near Amboise, at the invitation of Francis I.
 Draws up plans for Romorantin.

1519 2 May, Leonardo dies (in the King's arms, according to Vasari).